T0115682

ELMORE LEONARD'S 10 RULES OF WRITING

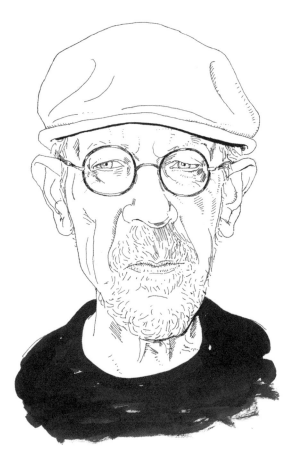

ELMORE LEONARD'S 10 RULES OF WRITING

Illustrations by
JOE CIARDIELLO

WILLIAM MORROW
An Imprint of HarperCollins*Publishers*

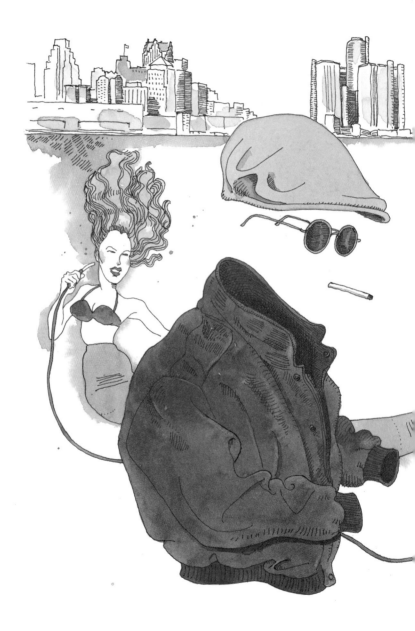

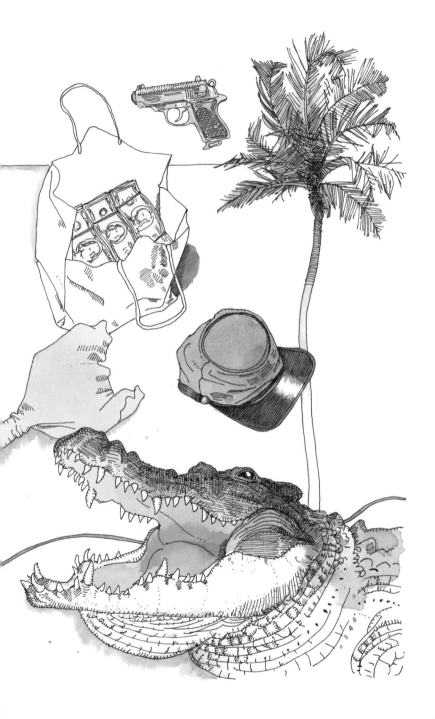

These are rules I've picked up along the way to help me remain invisible when I'm writing a book, to help me show rather than tell what's taking place in the story. If you have a facility for language and imagery and the sound of your voice pleases you, invisibility is not what you are after, and you can skip the rules. Still, you might look them over.

1.

NEVER OPEN A BOOK WITH WEATHER

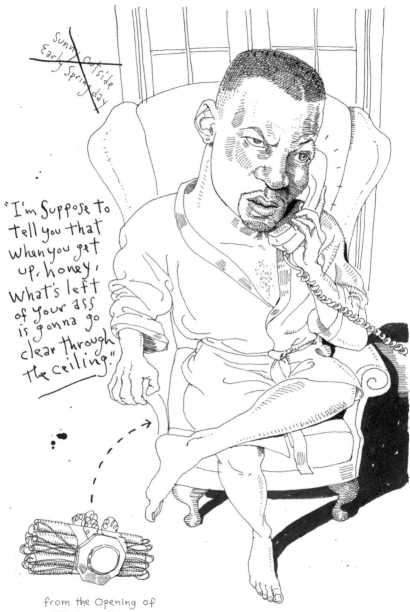

from the Opening of
FREAKY DEAKY

If it's only to create atmosphere, and not a character's reaction to the weather, you don't want to go on too long. The reader is apt to leaf ahead looking for people. There are exceptions. If you happen to be Barry Lopez, who has more ways than an Eskimo to describe ice and snow in his book *Arctic Dreams,* you can do all the weather reporting you want.

2.

AVOID PROLOGUES

They can be annoying, especially a prologue following an introduction that comes after a foreword.

But these are ordinarily found in nonfiction. A prologue in a novel is backstory, and you can drop it in anywhere you want.

There is a prologue in John Steinbeck's *Sweet Thursday,* but it's okay because a character in the book makes the point of what my rules are all about. He says:

"I like a lot of talk in a book and I don't like to have nobody tell me what the guy that's talking looks like. I want to figure out what he looks like from the way he talks . . . figure out what the guy's thinking from what he says. I like some description but not too much of that."

The Steinbeck character goes on to say, "Sometimes I want a book to break loose with a bunch of hooptedoodle. . . . Spin up some pretty words maybe or sing a little song with language. That's nice. But I wish it was set aside so I don't have to read it. I don't want hooptedoodle to get mixed up with the story."

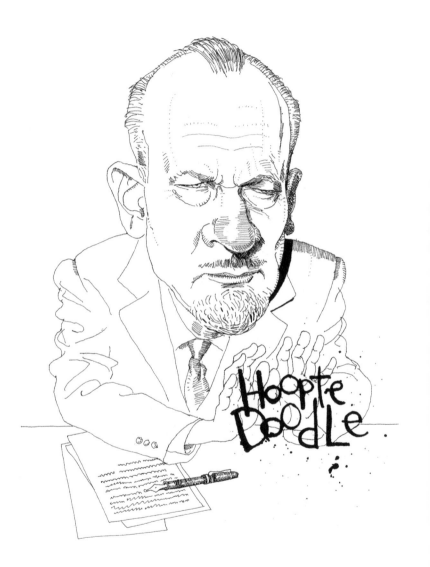

3.

NEVER USE A VERB OTHER THAN "SAID" TO CARRY DIALOGUE

The line of dialogue belongs to the character; the verb is the writer sticking his nose in. But "said" is far less intrusive than "grumbled," "gasped," "cautioned," "lied." I once noticed Mary McCarthy ending a line of dialogue with "she asseverated," and had to stop reading and go to the dictionary.

as·sev·er·ate (ə-sev'ə-rāt'), v.t.
[< L. < ad-, to + severus, severe], to state
seriously or positively. —as·sev'er·a'tion, n.

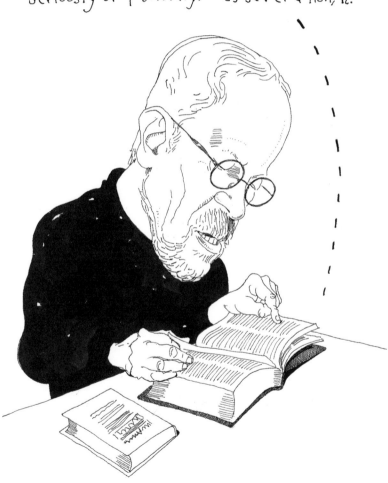

4.

NEVER USE AN ADVERB TO MODIFY THE VERB "SAID" . . .

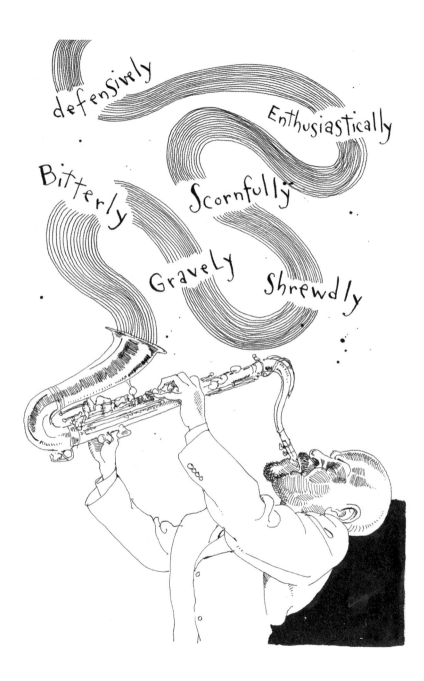

. . . he admonished gravely. To use an adverb this way (or almost any way) is a mortal sin. The writer is now exposing himself in earnest, using a word that distracts and can interrupt the rhythm of the exchange. I have a character in one of my books tell how she used to write historical romances "full of rape and adverbs."

5.

KEEP YOUR
EXCLAMATION POINTS
UNDER CONTROL

You are allowed no more than two or three per 100,000 words of prose. If you have the knack of playing with exclaimers the way Tom Wolfe does, you can throw them in by the handful.

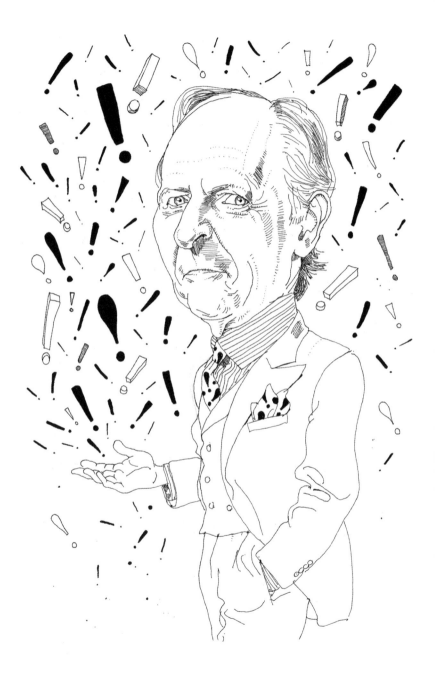

6.

NEVER USE THE WORDS "SUDDENLY" OR "ALL HELL BROKE LOOSE"

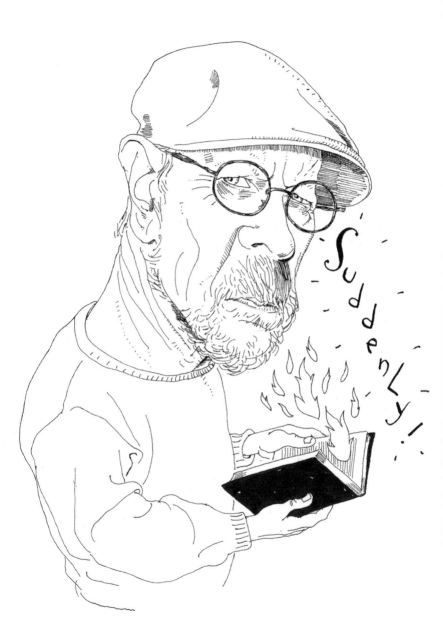

This rule doesn't require an explanation. I have noticed that writers who use "suddenly" tend to exercise less control in the application of exclamation points.

7.

USE REGIONAL DIALECT, PATOIS, SPARINGLY

"Roland was working for the EyetaLians down in Miami when a woman shot him, said he broke into her house.

...It was her pulled the trigger, yeah, but was this dink set it up.

He knew it was Roland in the house and told the woman it was Somebody broke in. 'Cause he didn't have the nerve to do it hisself. Understand?"

ELVIN Crowe from MAXIMUM BoB

Once you start spelling words in dialogue phonetically and loading the page with apostrophes, you won't be able to stop. Notice the way Annie Proulx captures the flavor of Wyoming voices in her book of short stories *Close Range*.

8.

AVOID DETAILED DESCRIPTIONS OF CHARACTERS

Which Steinbeck covered. In Ernest Hemingway's "Hills Like White Elephants," what do the "American and the girl with him" look like? "She had taken off her hat and put it on the table." That's the only reference to a physical description in the story, and yet we see the couple and know them by their tones of voice, with not one adverb in sight.

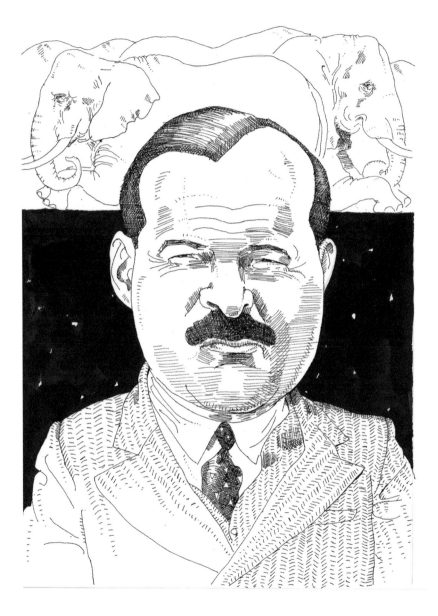

9.

DON'T GO INTO GREAT DETAIL DESCRIBING PLACES AND THINGS

Unless you're Margaret Atwood and can paint scenes with language or write landscapes in the style of Jim Harrison. But even if you're good at it, you don't want descriptions that bring the action, the flow of the story, to a standstill.

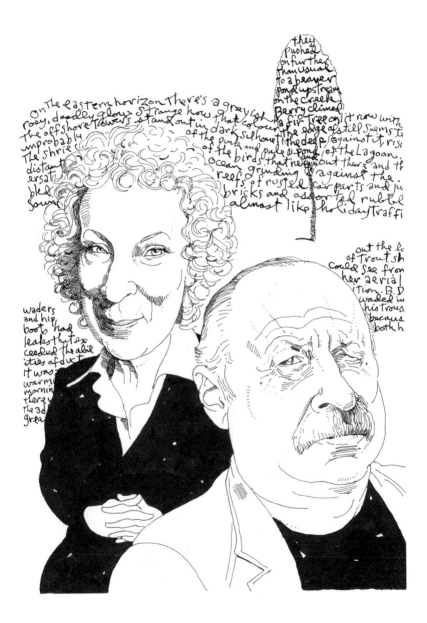

And finally:

10.

TRY TO LEAVE OUT THE PART THAT READERS TEND TO SKIP

A rule that came to mind in 1983, at lunch with Book-of-the-Month Club editors. Think of what you skip reading a novel: thick paragraphs of prose you can see have too many words in them.

What the writer is doing, he's writing, perpetrating hooptedoodle, perhaps taking another shot at the weather, or has gone into the character's head, and the reader either knows what the guy's thinking or doesn't care. I'll bet you don't skip dialogue.

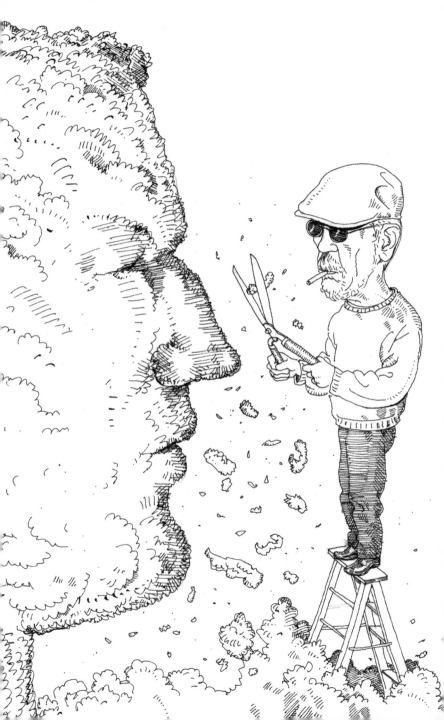

My most important rule is one that sums up the ten.

If it sounds like writing, I rewrite it.

Or, if proper usage gets in the way, it may have to go.

I can't allow what we learned in English composition to disrupt the sound and rhythm of the narrative.

It's my attempt to remain invisible, not distract the reader from the story with obvious writing.

(Joseph Conrad said something about words getting in the way of what you want to say.)

If I write in scenes and always from the point of view of a particular character—the one whose view best brings the scene to life—I'm able to concentrate on the voices of the characters telling you who they are and how they feel about what they see and what's going on, and I'm nowhere in sight.

What Steinbeck did in *Sweet Thursday* was title his chapters as an indication, though obscure, of what they cover. "Whom the Gods Love They Drive Nuts" is one, "Lousy Wednesday" another. The third chapter is titled "Hooptedoodle 1" and the thirty-eighth chapter "Hooptedoodle 2" as warnings to the reader, as if Steinbeck is saying: "Here's where you'll see me taking flights of fancy with my writing, and it won't get in the way of the story. Skip them if you want."

Sweet Thursday came out in 1954, when I was just beginning to be published, and I've never forgotten that prologue.

Did I read the hooptedoodle chapters?

Every word.

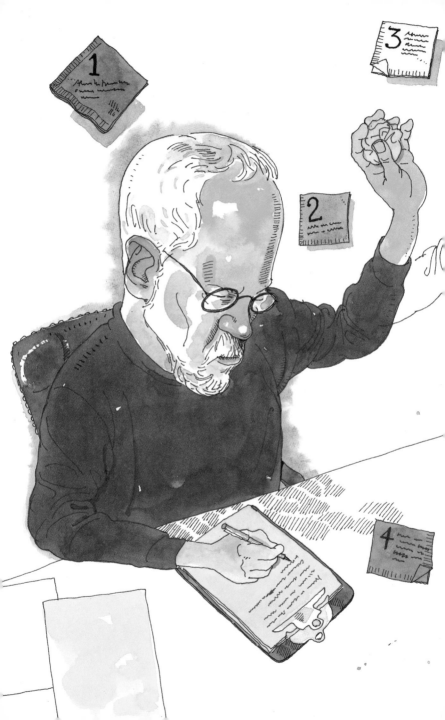

Joseph Conrad

Library of Congress Cataloging-in-Publication Data

Leonard, Elmore, 1925–
 Elmore Leonard's 10 rules of writing / Elmore Leonard ; illustrations by Joe Ciardiello.—1st ed.
 p. cm.
"Originally published July 16, 2001 in the New York Times as 'Easy on the Adverbs, Exclamation Points, and Especially Hooptedoodle'"—T.p. verso.250
 ISBN 978-0-06-145146-1—ISBN 978-0-06-145148-5 (limited edition)
1. Leonard, Elmore, 1925– —Authorship. I. Ciardiello, Joseph. II. Title.
III. Title: 10 rules of writing. IV. Title: Ten rules of writing.

PS3562.E55Z46 2007
808.3—dc22

 2007044042

23 SCP 10 9 8